To Look at Any Thing

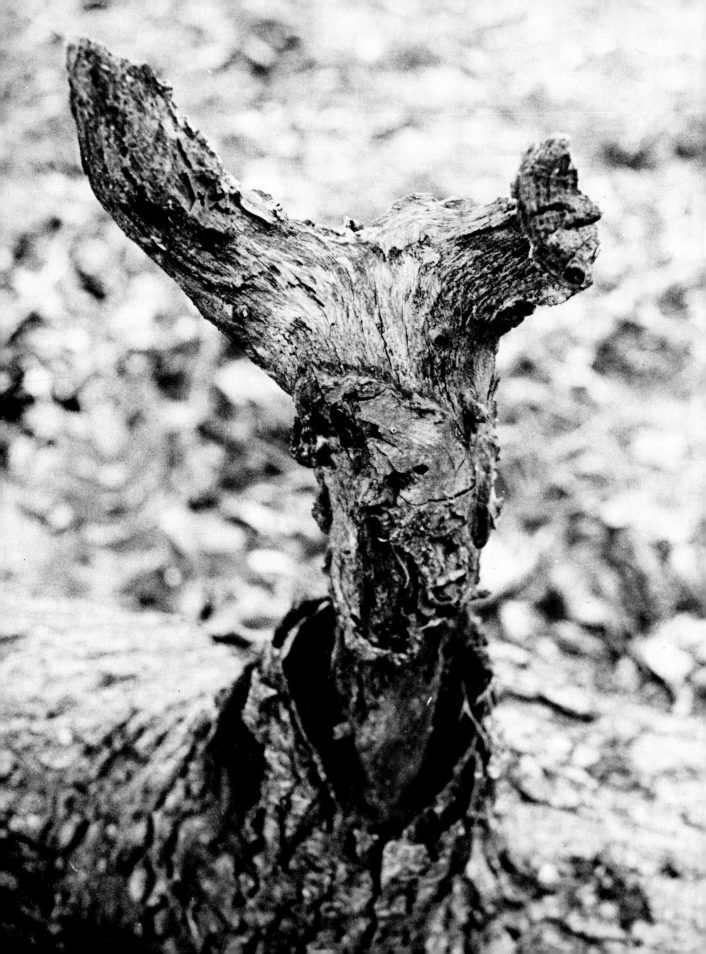

To Look at Any Thing

POEMS SELECTED BY *Lee Bennett Hopkins*

PHOTOGRAPHS BY *John Earl*

HBJ

HARCOURT BRACE JOVANOVICH

NEW YORK AND LONDON

Library of Congress Cataloging in Publication Data
Main entry under title:

To look at anything.

Includes index.
SUMMARY: Includes selections by Langston Hughes,
Dag Hammarskjöld, and Walt Whitman.
1. Children's poetry. [1. Poetry—Collections]
I. Hopkins, Lee Bennett. II. Earl, John.
PN6110.C4T74 808.81 77–88962
ISBN 0–15–289083–1

Printed in the United States of America

First edition
B C D E F G H I J K

To Donna Lea and Anthony Venturi
and also

to Sandy West who so graciously
allowed the photographing of some
of her very special "nature people"
who live on Ossabaw Island, Georgia

To Look at Any Thing

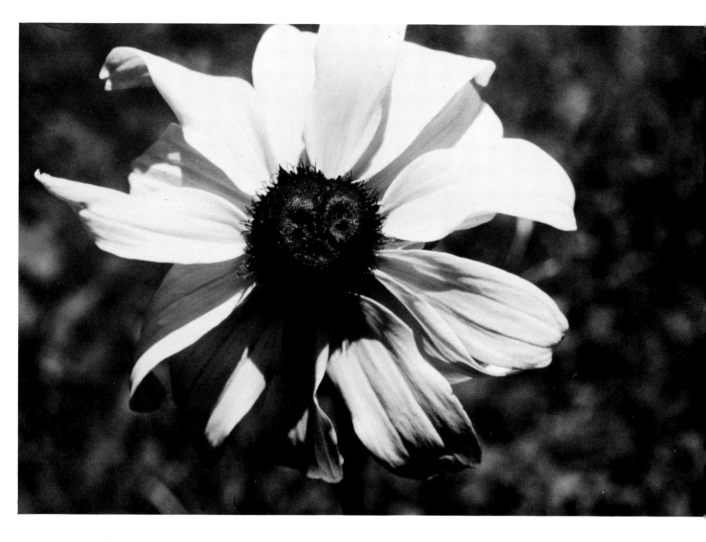

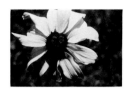

To Look at Any Thing

JOHN MOFFITT

To look at any thing,
If you would know that thing,
You must look at it long:
To look at this green and say,
'I have seen spring in these
Woods,' will not do—you must
Be the thing you see:
You must be the dark snakes of
Stems and ferny plumes of leaves,
You must enter in
To the small silences between
The leaves,
You must take your time
And touch the very peace
They issue from.

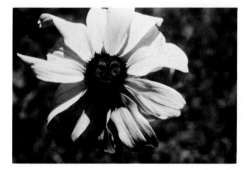

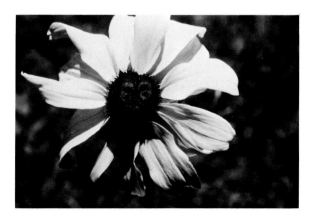

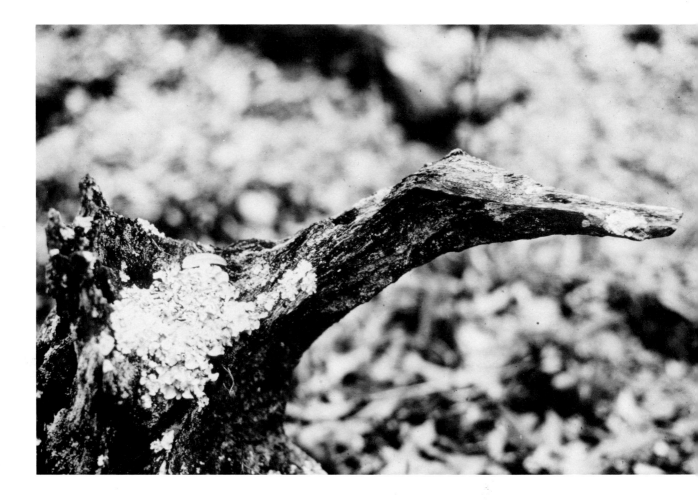

288

EMILY DICKINSON

I'm Nobody! Who are you?
Are you—Nobody—Too?
Then there's a pair of us?
Don't tell! they'd advertise—you know!

How dreary—to be—Somebody!
How public—like a Frog—
To tell one's name—the livelong June—
To an admiring Bog!

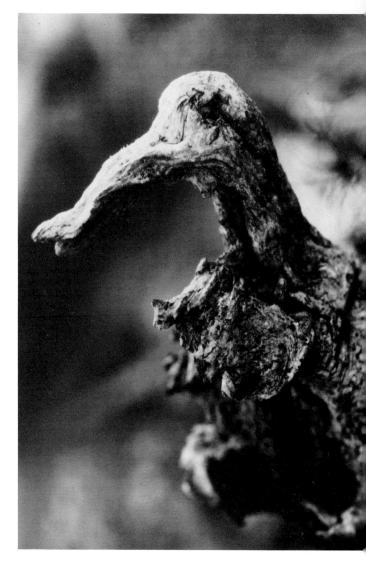

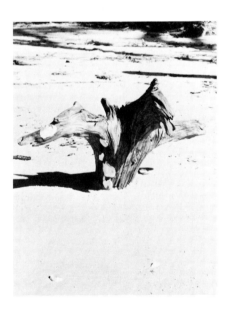

The Secret Sits

ROBERT FROST

We dance round in a ring and suppose,
But the Secret sits in the middle and knows.

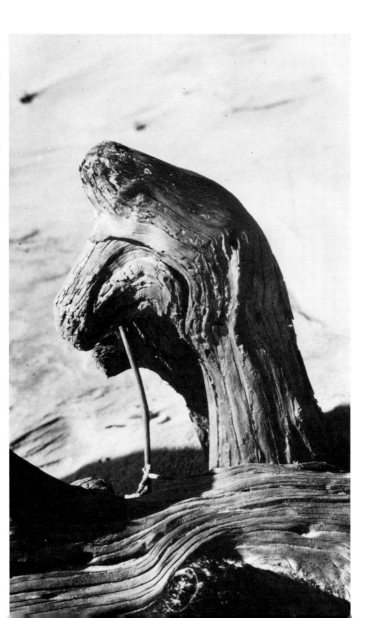

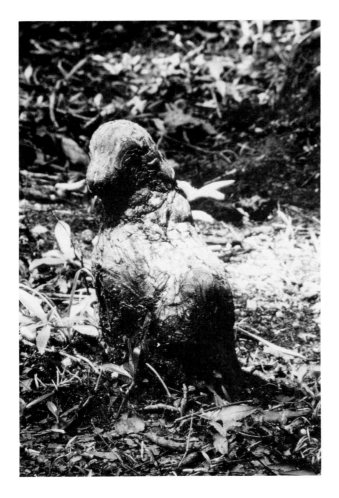

Who Am I?

FELICE HOLMAN

The trees ask me,
And the sky,
And the sea asks me
 Who am I?

The grass asks me,
And the sand,
And the rocks ask me
 Who I am.

The wind tells me
At nightfall,
And the rain tells me
 Someone small.

 Someone small
 Someone small
 But a piece
 of
 it
 all.

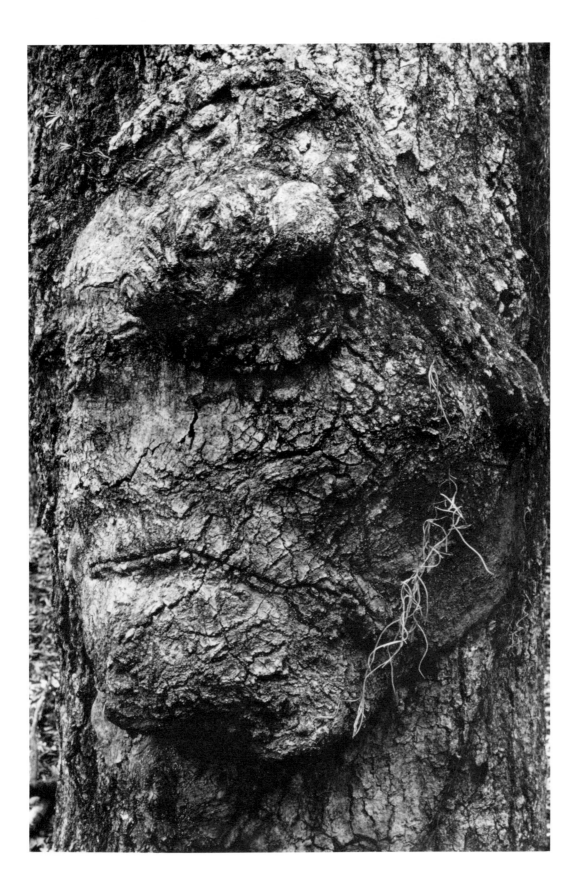

Change

CHARLOTTE ZOLOTOW

The summer
still hangs
heavy and sweet
with sunlight
as it did last year.

The autumn
still comes
showering gold and crimson
as it did last year.

The winter
still stings
clean and cold and white
as it did last year.

The spring
still comes
like a whisper in the dark night.

It is only I
who have changed.

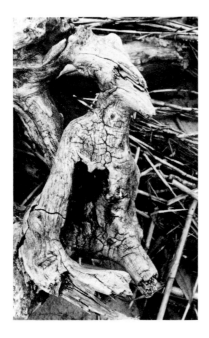

Hope

LANGSTON HUGHES

Sometimes when I'm lonely,
Don't know why,
Keep thinkin' I won't be lonely
By and by.

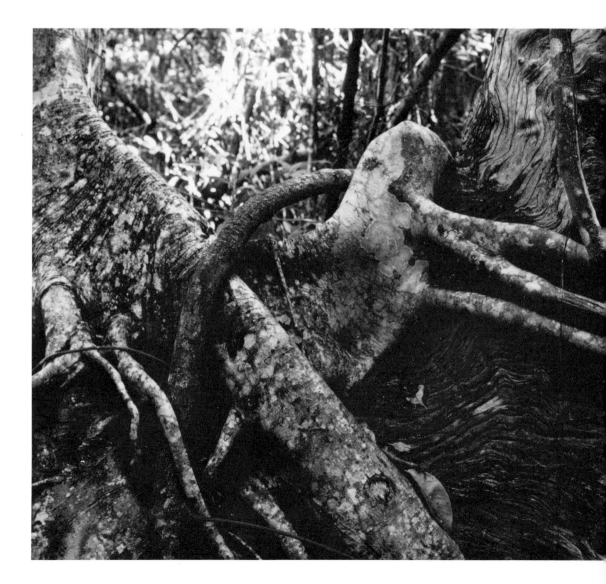

These Days

CHARLES OLSON

Whatever you have to say, leave
the roots on, let them
dangle

And the dirt
 just to make clear
 where they came from

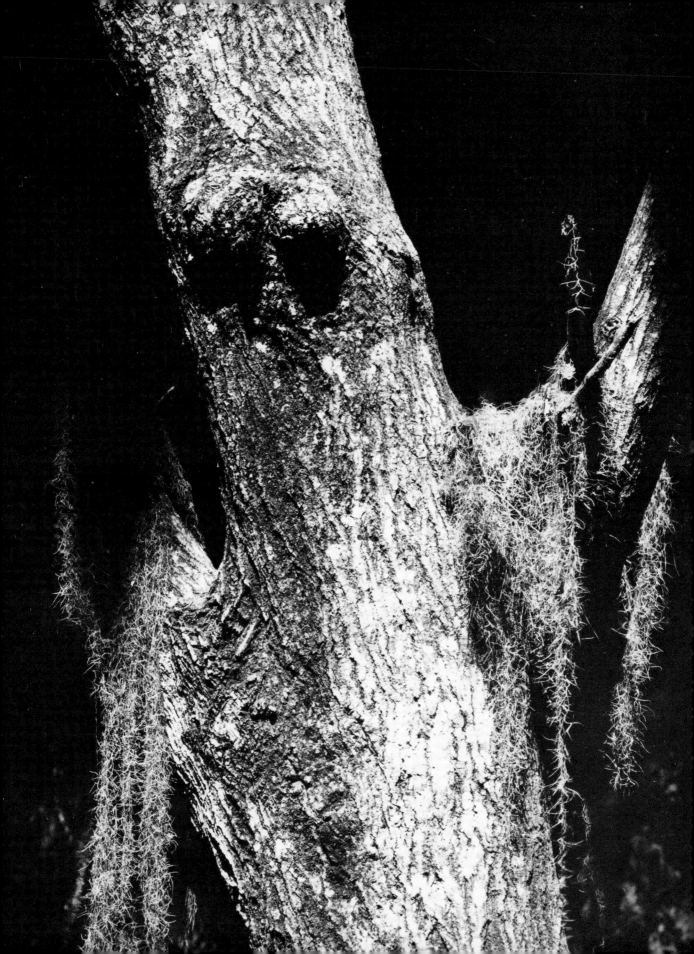

From a Cornish Litany

ANONYMOUS

From Ghoulies and Ghosties,
And long-leggity Beasties,
And all Things that go bump in the Night,
Good Lord deliver us.

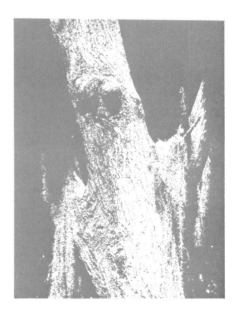

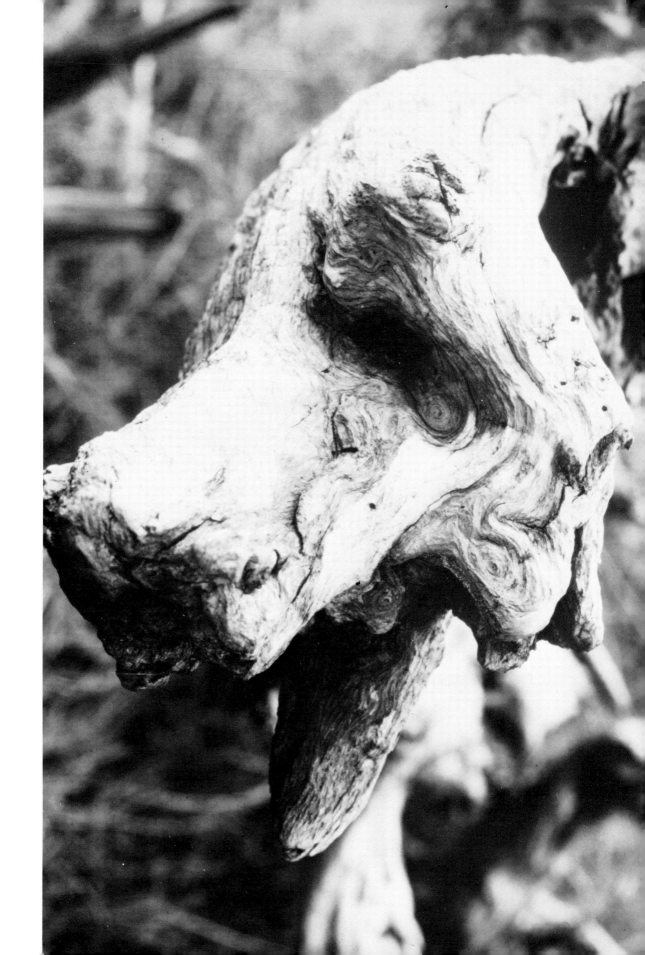

Lone Dog

IRENE RUTHERFORD McLEOD

I'm a lean dog, a keen dog, a wild dog, and lone;
I'm a rough dog, a tough dog, hunting on my own!
I'm a bad dog, a mad dog, teasing silly sheep;
I love to sit and bay the moon, to keep fat souls from sleep.

I'll never be a lap dog, licking dirty feet,
A sleek dog, a meek dog, cringing for my meat,
Not for me the fireside, the well-filled plate,
But shut door, and sharp stone, and cuff and kick and hate.

Not for me the other dogs, running by my side,
Some have run a short while, but none of them would bide.
O mine is still the one trail, the hard trail, the best
Wide wind, and wild stars, and hunger of the quest!

When Dinosaurs Ruled the Earth

PATRICIA HUBBELL

Brontosaurus, diplodocus, gentle trachodon,
Dabbled in the muds of time,
Once upon, upon.

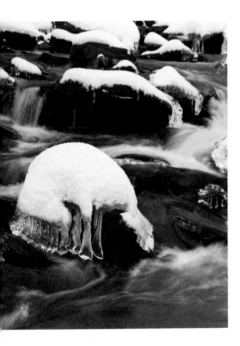

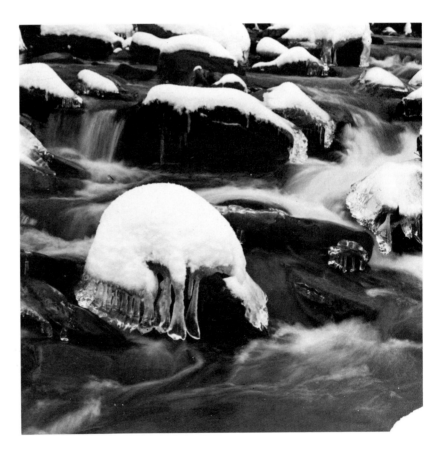

Tyrannosaurus raised his head
And rolled his evil eye,
Bared his long and yellow teeth
And bid his neighbors 'bye.
His pygmy brain was slow to grasp
The happenings of the day,
And so he roamed and slew his friends
And ate without delay.

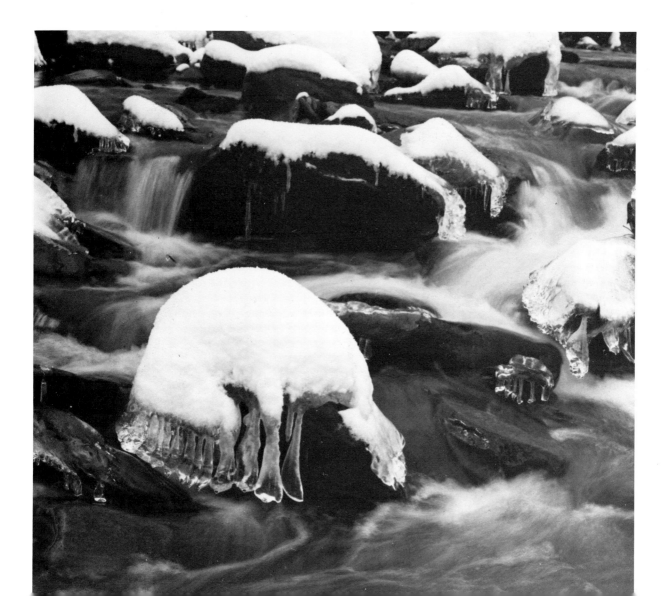

Brontosaurus, diplodocus, gentle trachodon,
Dabbled in the muds of time,
Once upon, upon.

Allosaurus awed his foe,
He awed his friends who passed,
His teeth were made for tearing flesh,
His teeth were made to gnash.
Taller than a building now,
Taller than a tree,

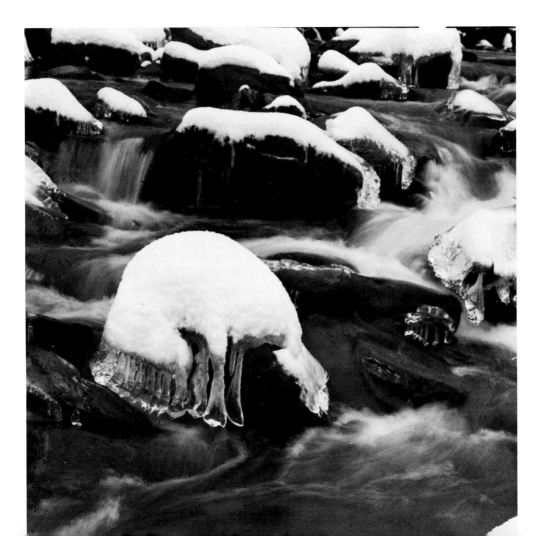

He roamed about the swamp-filled world
And ate his company.

Brontosaurus, diplodocus, gentle trachodon,
Dabbled in the muds of time,
Once upon, upon.

Eaters of their friends and foe
Or dabblers in the slime,
Their pygmy brains were slow to grasp,
Once upon a time.

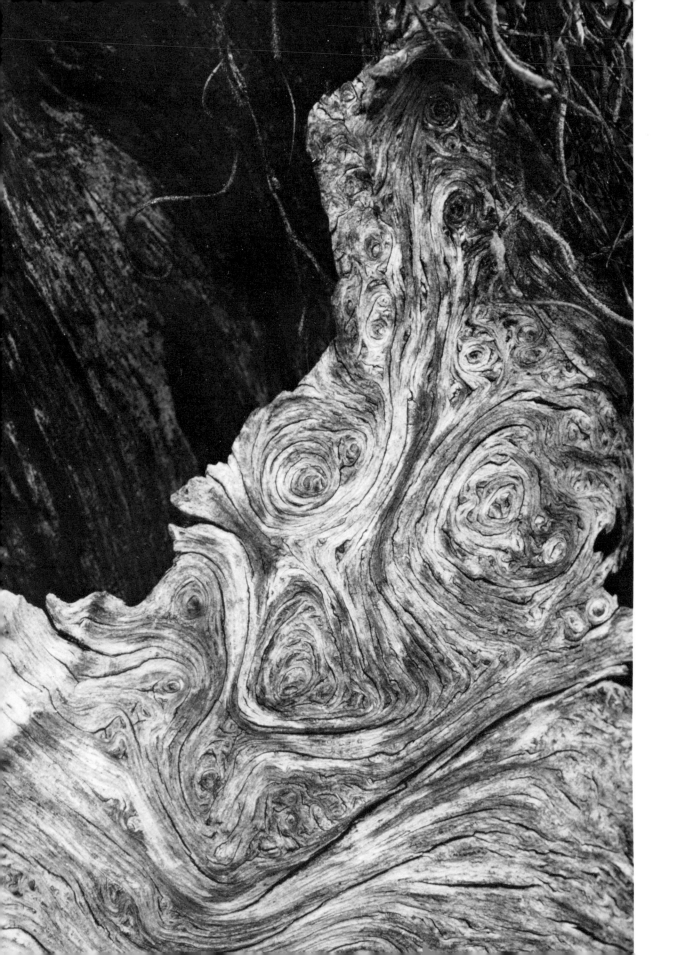

Beginnings of Thoughts

PATRICIA HUBBELL

My mind feels still.
A stretch of snow, barren of footprints.
No tracks reveal themselves beneath the bordering bushes.

No faint, far call intrudes, to turn itself to thought.
My mind stares down the drift.
I follow.
Somewhere,
 Somehow,
 Slowly,
 In that dim and silent world,
 The tracks begin.

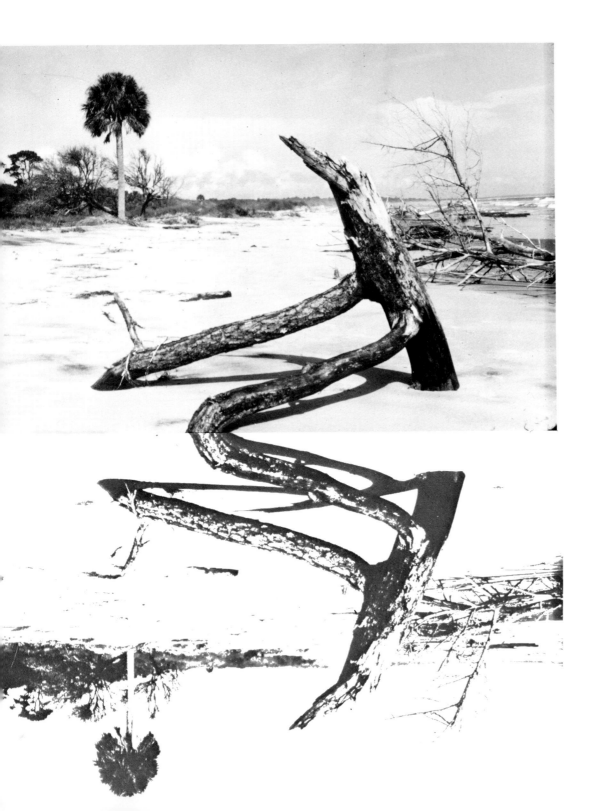

from
As for Poets

GARY SNYDER

The first
Water Poet
Stayed down six years.
He was covered with seaweed
The life in his poem
Left millions of tiny
Different tracks
Criss-crossing through the mud.

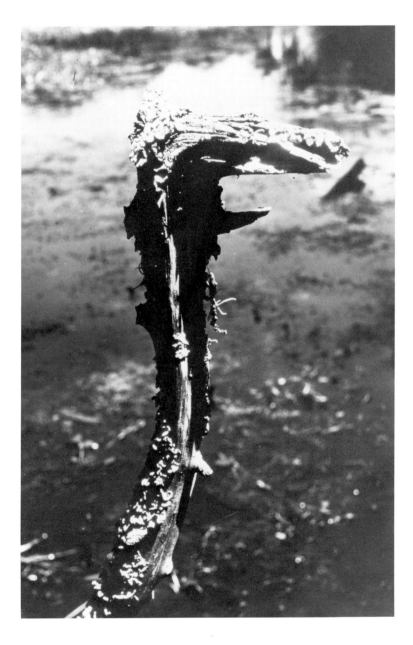

Sea Spirit

PATRICIA HUBBELL

Curtains of seaweed,
Blankets of mist,
Walls of a coral bank
Sea-foam kissed.
This is my home
In the depth of the ocean,
This is the place
Where love and devotion
Follow a pattern of
Sea-spun emotion.
On mussels and mollusks
The light filters down
And makes near my home
An enchanted sea town
Where mermen and maidens
And sea horses romp,
In fields filled with seaweed
On mountains of coral
On plains of white sand
On the floor of the ocean.

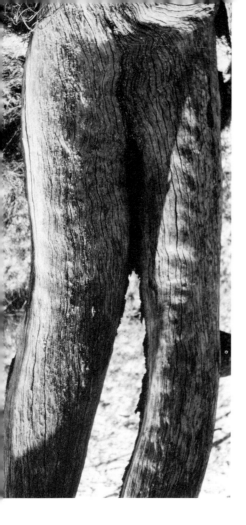

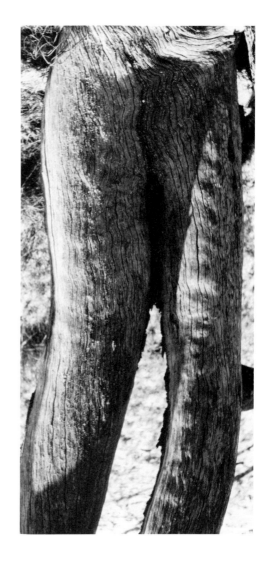

from
Markings

DAG HAMMARSKJÖLD

Never look down to test the ground before taking your next step: only he who keeps his eye fixed on the far horizon will find his right road.

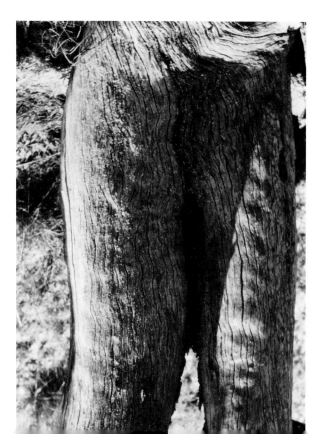

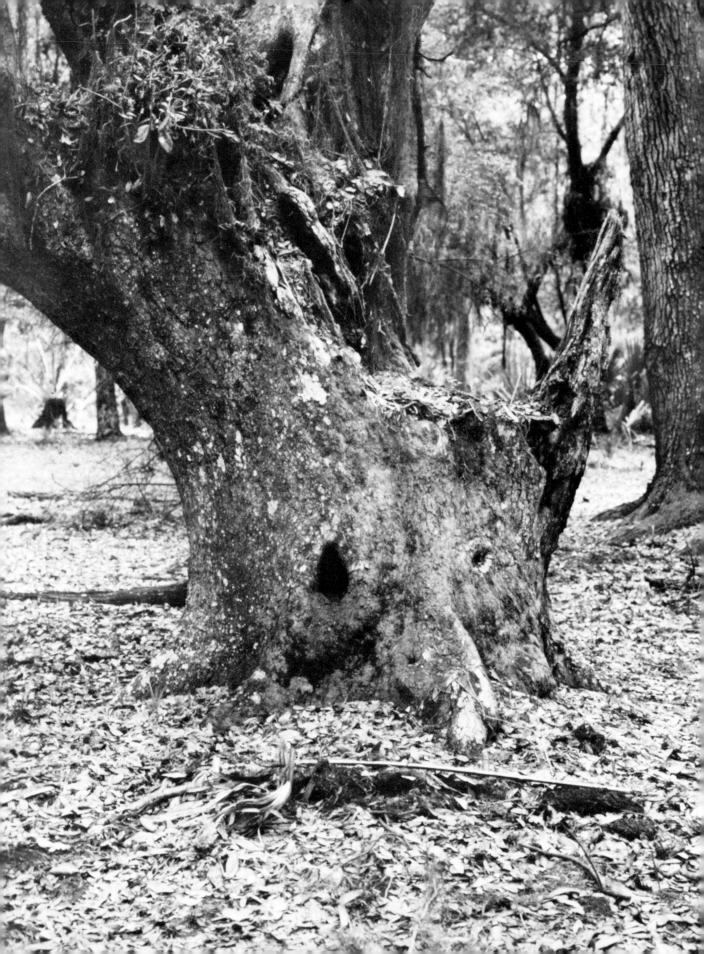

The Troll

JACK PRELUTSKY

Be wary of the loathsome troll
that slyly lies in wait
to drag you to his dingy hole
and put you on his plate.

His blood is black and boiling hot,
he gurgles ghastly groans.
He'll cook you in his dinner pot,
your skin, your flesh, your bones.

He'll catch your arms and clutch your legs
and grind you to a pulp,
then swallow you like scrambled eggs—
gobble! gobble! gulp!

So watch your steps when next you go
upon a pleasant stroll,
or you might end in the pit below
as supper for the troll.

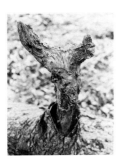

Encounter

LILIAN MOORE

We both stood
heart-stopping
still,

I
in the doorway
the deer
near
the old apple tree,

he
muscle wary
straining
to hear

I
holding breath
to say
do not fear.

In the silence
between us
my thought said
Stay!

Did it snap
like
a twig?
He rose on a curve
and fled.

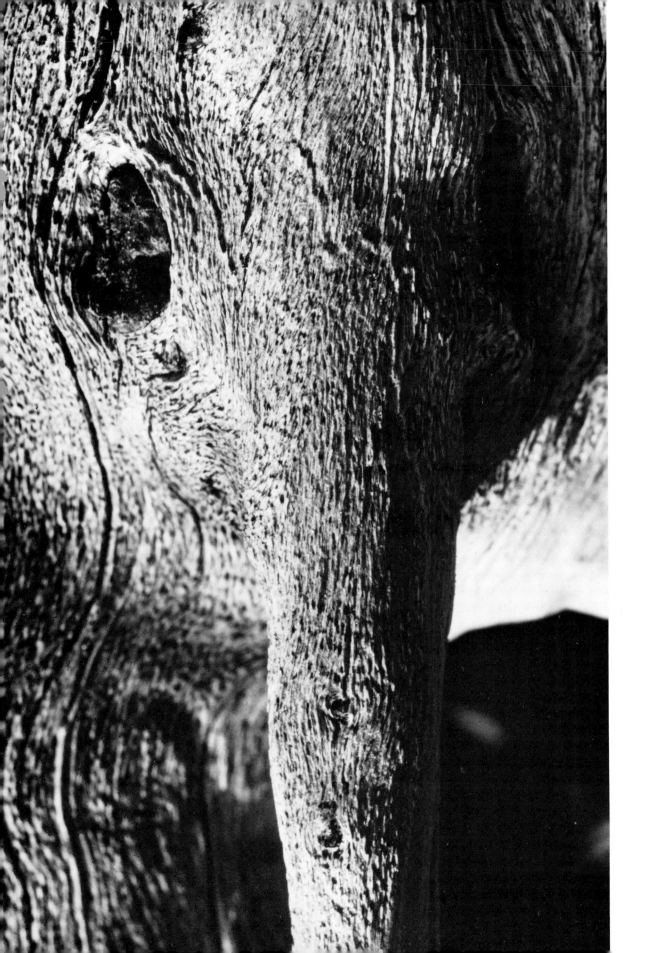

Pete at the Zoo

GWENDOLYN BROOKS

I wonder if the elephant
Is lonely in his stall
When all the boys and girls are gone
And there's no shout at all,
And there's no one to stamp before,
No one to note his might.
Does he hunch up, as I do,
Against the dark of night?

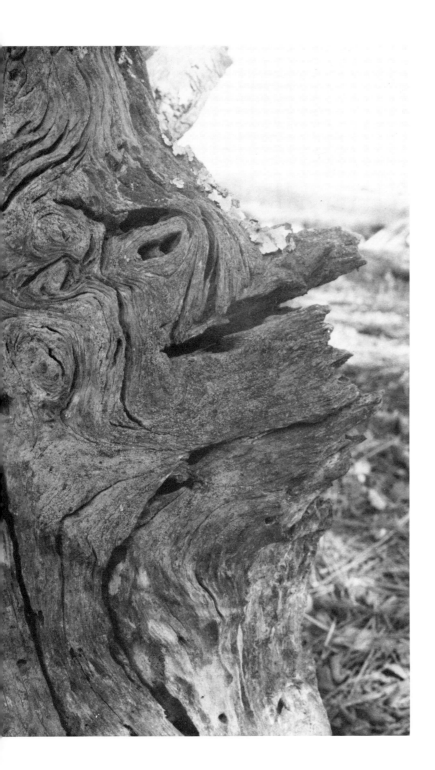

The Story-Teller

MARK VAN DOREN

He talked, and as he talked
Wallpaper came alive;
Suddenly ghosts walked,
And four doors were five;

Calendars ran backward,
And maps had mouths;
Ships went tackward
In a great drowse;

Trains climbed trees,
And soon dripped down
Like honey of bees
On the cold brick town.

He had wakened a worm
In the world's brain,
And nothing stood firm
Until day again.

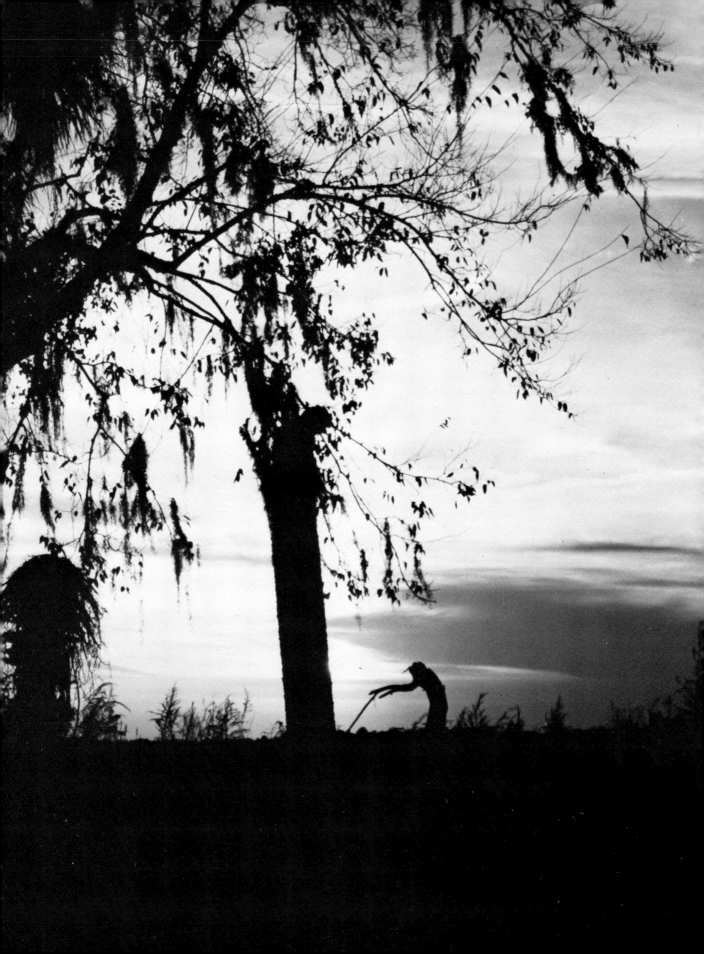

from
Song of the Open Road

WALT WHITMAN

You road I enter upon and look around, I believe you are not
all that is here,
I believe that much unseen is also here.

 • • •

Now I see the secret of the making of the best persons,
It is to grow in the open air and to eat and sleep with the
earth.

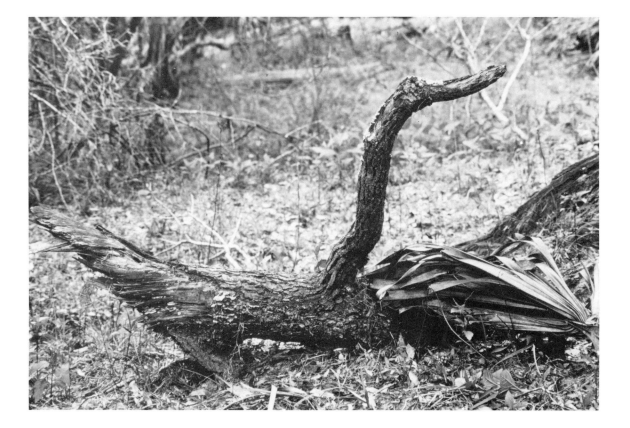

from

Dreams

LANGSTON HUGHES

Hold fast to dreams
For if dreams die
Life is a broken-winged bird
That cannot fly.

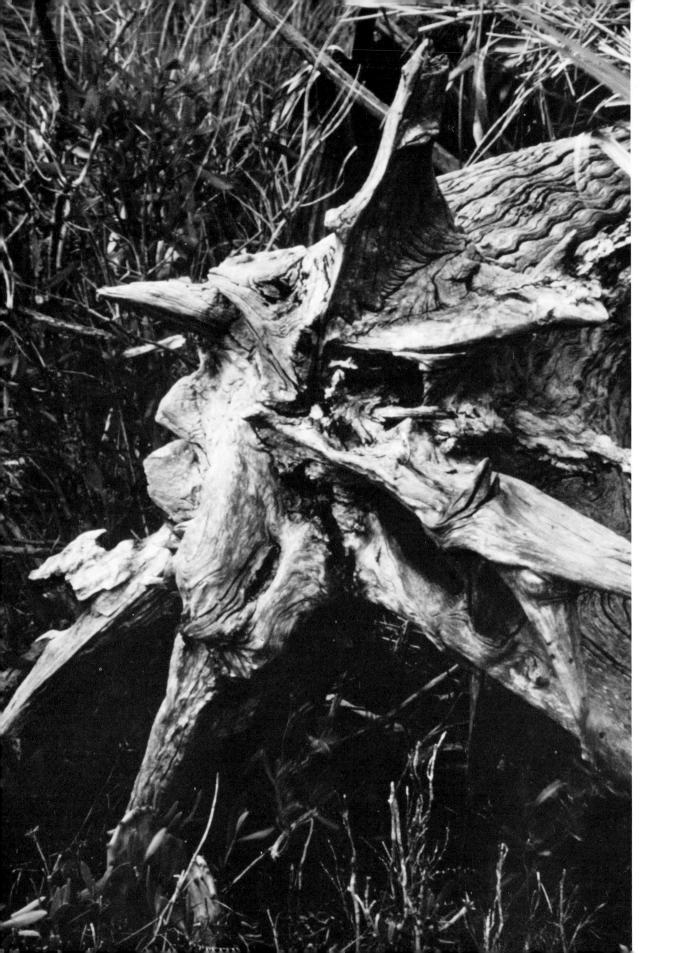

from
Starting from Paumanok

WALT WHITMAN

This then is life,
Here is what has come to the surface after so many throes
 and convulsions.

How curious! how real!
Underfoot the divine soil, overhead the sun.

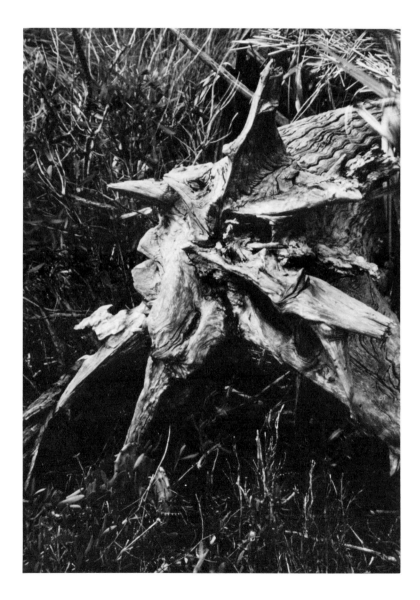

Index